SCULPTURE FROM NOTRE-DAME, PARIS

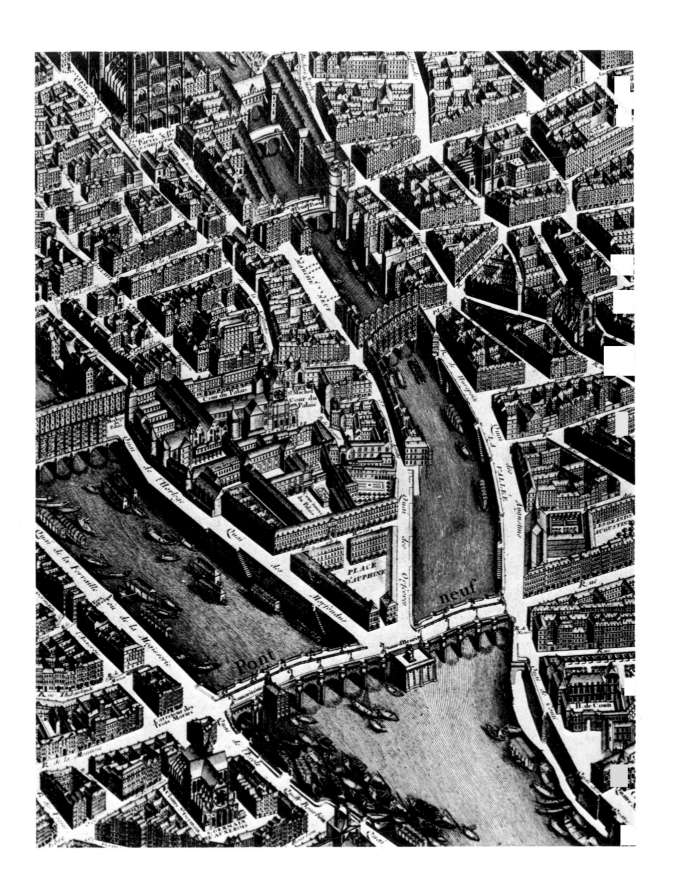

SCULPTURE FROM NOTRE-DAME, PARIS:

A DRAMATIC DISCOVERY

BY CARMEN GÓMEZ-MORENO

Curator, Department of Medieval Art
The Metropolitan Museum of Art

Exhibited September 6 - November 25, 1979

The Metropolitan Museum of Art, New York

December 15, 1979 - January 27, 1980

The Cleveland Museum of Art

COVER
9. *Head of king no. 14, French, Paris, about 1230-40.*
6. *Head of an angel. French, Paris, about 1230.*

FRONTISPIECE
An aerial view of the Ile de la Cité, as shown in an eighteenth-century engraving. The Cathedral of Notre-Dame appears in the upper left-hand corner.

Unless otherwise credited, the photographs are by Florin Dragu, Paris. The illustrations on pages 6, 7, 12, 13, 16, 18, 20, 22, 24, and 29 are reproduced by permission of Joël Cuénot, Paris, publishers of *Les Rois retrouvés,* where they first appeared. The plan of Notre-Dame, page 11, was redrawn by Barbara Zapatka.

Published by The Metropolitan Museum of Art, New York
Bradford D. Kelleher, Publisher
John P. O'Neill, Editor in Chief
Polly Cone, Editor
Peter Oldenburg, Designer

The exhibition at the Metropolitan Museum is made possible by a generous grant from Interpace Corporation.

LIBRARY OF CONGRESS CATALOGING IN PUBLICATION DATA
Gómez-Moreno, Carmen.
 Sculpture from Notre-Dame, Paris.
 Catalog of an exhibition.
 Bibliography: p.
 1. Sculpture, Gothic—France—Paris—Exhibitions.
2. Sculpture, French—France—Paris—Exhibitions.
3. Head in art—Exhibitions. 4. Paris. Notre-Dame (Cathedral)—Exhibitions. I. New York (City).
Metropolitan Museum of Art. II. Title
NB550.G65 730'.944'361 79-18998
ISBN 0-87099-211-2

Foreword

In the field of medieval archaeology the most important and dramatic recent discovery is unquestionably that of 364 fragments of statuary that originally adorned one of the greatest cathedrals of the Gothic age, Notre-Dame de Paris. This extraordinary find, which took place just over two years ago, in April 1977, was well documented by records providing specific details on the sculptures' deliberate destruction—one of the more perverse acts of Revolutionary fanaticism. Not only did the discovery measurably increase our knowledge of Gothic sculpture during its classic period, 1150–1250, but it also resurrected works of haunting beauty.

It is most appropriate that the Metropolitan and the Cleveland Museums of Art, two American museums with long and strong traditions of collecting in the field of medieval art, should collaborate in arranging an exhibition drawn from this extraordinary group of sculptures. Furthermore, it is pure serendipity that William Wixom, former Curator of Medieval Art at the Cleveland Museum and the recently appointed Chairman of the Metropolitan Museum's Department of Medieval Art and The Cloisters, should be the coordinator of this particular collaborative venture between our two museums.

Our deep gratitude goes to the lender of the sculptures, François Giscard d'Estaing, President of the Banque Française du Commerce Extérieur. We would also like to thank both Hubert Landais, Director of the Musées de France, and Irène Bizot, Head of Exhibition Services, for their invaluable support and cooperation at every stage in the preparation of the exhibition.

Generous funding from Interpace Corporation made the exhibition possible at the Metropolitan.

<div align="right">

PHILIPPE DE MONTEBELLO
Director, The Metropolitan Museum of Art

SHERMAN LEE
Director, The Cleveland Museum of Art

</div>

Acknowledgments

All the facts of the discovery of 1977 have been published by François Giscard d'Estaing in *Archéologia* 108, 1977, and in *Les Rois retrouvés,* Paris, 1977.

The historical documents from the Revolution have been published by Michel Fleury, Director of Historical Antiquities for Paris and the Ile-de-France, in the same publications. Alain Erlande-Brandenburg, Curator and Acting Director of the Musée de Cluny, is responsible for the art-historical accounts of the discovery that appear in the above publications and has been of valuable assistance in the preparation of both the exhibition and this catalogue. The factual information in the present study has been taken largely from both the magazine and the book.

April 1977: The Discovery

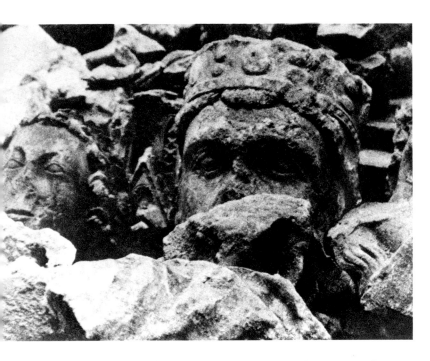

Some of the sculptural fragments at the scene of the 1977 discovery, immediately after being removed from the ground. On the left is the head of an angel (no. 6).

A drawing by F. A. Pernot, 1840, showing several of the fragmentary bodies from Notre-Dame being used as supports for the wall of a coal market on the rue de la Santé, Paris.

ONE OF THE MOST important discoveries of all time in the field of medieval art took place in April 1977 in the city of Paris. No years of planning, no archaeological expedition, no national or international funding was involved—just luck. While doing some routine work to find a leak that was endangering the foundations of the Hôtel Moreau, at 20, rue de la Chaussée-d'Antin, workmen had to remove part of the pavement of a courtyard. After digging through about two and a quarter feet (.70 meters) of stratifications of different kinds of soil, they uncovered a ditch measuring about fourteen and a half feet (4.40 meters) long, five and a quarter feet (1.60 meters) deep, and two and a quarter feet (.70 meters) wide. The ditch contained many blocks of stone—364, to be exact—carefully set in four layers. The spaces between blocks were filled in with enough plaster to keep the stones from rubbing against each other, but the plaster was loose enough to allow the stones to be removed without damage. When the first block was taken out of the ditch and turned over, the puzzled discoverers found that it was a head, and a crowned one at that. The proper authorities were alerted, and under the supervision of M. Jean Cottier, then president of the Banque Française du Commerce Extérieur, which owns the Hôtel Moreau, and M. François Giscard d'Estaing, then general director of the bank, the unearthing of the stones was carefully completed.

It was obvious from the start that the sculptural fragments had been buried with utmost care. The heads were placed face down to provide better and more cushioned protection, and small fragments filled in the spaces between the larger ones. The big crowned heads, about twenty-six inches (66

centimeters) high, seemed to be Gothic in style and had to have come from a very large church in Paris, as it did not seem logical that whoever had buried them at the rue de la Chaussée-d'Antin would have brought them from outside the city. It was known and documented that the sculptures of the Cathedral of Notre-Dame had been destroyed during the French Revolution, but no traces were ever found of most of them. In 1839 fifteen fragmentary sculptural bodies were found used as supports along the wall of the coal market on the rue de la Santé, and a headless figure was fished out of the Seine in 1880. André Malraux, with his poetic imagination, wrote that "the people of Paris had thrown the symbols of tyranny into the Seine."

The heads dug up on the grounds of the Hôtel Moreau were positioned face down, and turned slightly to the south—in the direction of Notre-Dame—as if to convey a message that would indicate their origin if ever they were found.

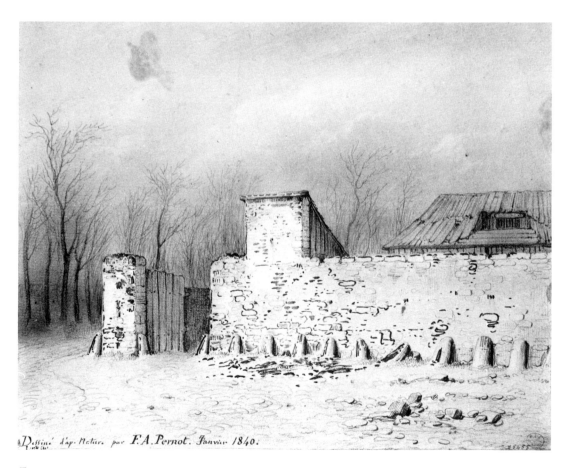

Dessiné d'ap. Nature par F.A. Pernot. Janvier 1840.

July-October 1793: The Destruction

TO EXPLAIN the fantastic discovery of the spring of 1977, one has to go back to the rather gruesome and hard-to-believe history of the destruction of the sculptures. Among the many victims of the French Revolution, these sculptures were possibly the most innocent and undeserving. They were not destroyed by the mob in the heat of passion in the initial and uncontrollable events; they did not stand a more or less legal trial; they were simply massacred by decree.

In July 1793, exactly four years after the assault on the Bastille, the Ministry of the Interior gave orders to destroy "all signs of superstition and feudalism." Documents preserved in the National Archives describe in minute detail the whole operation. From September to October, following the orders of the Commune, the citizen Bazin, a contractor, chipped off the fleurons on the crowns of the queens and kings of Notre-Dame, as he had already done on other buildings with royal representations around the city. But that was not enough. On October 23 the General Council of the Commune reported that in spite of the law, there were still monuments to fanaticism and royalty in the streets of Paris and that within eight days the Gothic likenesses of the kings of France on the facade of Notre-Dame (by now referred to as "the Temple of Reason") must be toppled and destroyed. Another contractor, Varin, received the commission and had a scaffolding erected for the purpose of carrying it out. The sculptures are described as being made of very hard stone, and, moreover, those of the twenty-eight kings were attached to the wall behind them by iron clamps. The heads must have been severed before the rest of the statues were dealt with, because those found in 1977 are broken at the neck, and rather evenly. If entire statues had fallen to the street below

Notre-Dame, part of the shoulders might have been preserved, even if the heads were not complete. Before the headless statues could be thrown to the ground, they had to be freed from the iron attachments and the stone about the shoulders chipped off to make them narrow enough to pass through the colonnade. After this the statues were pried away from the facade by means of a lever and sent crashing to the ground.

By the time his nefarious work was done, Varin had destroyed seventy-eight large sculptures and twelve smaller ones from Notre-Dame alone, without counting parts of columns and other architectural elements that had royal emblems. The work was done thoroughly, efficiently, and quickly.

The pavement in front of the west facade of the cathedral caved in under the weight of the destroyed sculptures, and in order to fix it and to keep the space in front of the building clear, workmen piled the sculptures on the north side of the cathedral along the cloister and what is now known as the rue Cloître-de-Notre-Dame.

All the heads lost their noses and other parts of their faces when they fell, and some broke up completely. The "patriot Palloy" took three of the heads of the kings (probably among the best ones preserved) and offered them as trophies to the districts of l'Egalité (Bourg-la-Reine), Franciade (Saint-Denis), and Sceaux (l'Unité). These were not the only sculptures separated from the rest. There were the fifteen fragmentary bodies found in 1839, the one found in the Seine, and a head identified as that of King David, which was acquired by The Metropolitan Museum of Art in 1938. Others were scattered and lost, many of them probably reused as construction material.

The mountain of broken sculptures remained in front of the north facade for three years and

was the object of much comment, mostly derogatory, though there were probably many Parisians who secretly lamented the destruction as a sacrilege. It is shocking to read that an artist whose exquisite taste is proverbial, Jacques-Louis David, proposed to the Assembly that the mountain of broken sculptures from Notre-Dame be used as a base for a monument to the everlasting glory of the French people. This monument was to be erected on the west end of the Ile de la Cité, on the Pont Neuf, where the monument to Henry IV stood before the Revolution. The project, though seriously considered, was never carried out.

The writer and historian Sebastien Mercier described quite graphically the broken statues forming a mountain covered with all kinds of filth in the cloister on the north side of the cathedral. He also described their attributes, as kings of France, when we know that all the attributes had already been removed, making his identifications impossible. The misidentification of the statues from the Gallery of the Kings as kings of France had appeared as early as the thirteenth century, in a text called *Manières de vilains,* in which a simpleton looks openmouthed at the kings and recognizes among them Pepin, Charlemagne, and all the others. In 1612 Dom du Breul, a Benedictine monk from Saint-Germain-des-Près, in his *Théâtre des antiquités de Paris,* gave a partial list of the worthies he thought he could identify. He started with Childebert, the Merovingian king and patron of the original basilica on the site of Notre-Dame, and ended with Philip Augustus, during whose reign the Gallery of the Kings was built (1180-1223).

The mistake of considering the figures from the Gallery of the Kings representations of the kings of France instead of the biblical kings of Judah, ancestors of Jesus Christ—which is what they really were—proved to be fatal. The destruction of those monumental sculptures, now reduced to fragments that only give us an idea of their past beauty and grandeur, was a clear case of mistaken identity. It is unlikely that the destruction would have been so deliberate and complete had those who carried it out realized that the sculptures were biblical representations, examples of "religious fanaticism."

1796: The Rescue and the Burial

By MARCH 1796 the mountain of broken statues was still in front of the north facade of the cathedral; it had become a garbage dump, causing a serious sanitation problem, and the citizens living in or passing by the area were complaining. An investigation was started to find a way to dispose of the offensive mound, but in those days there were no easy means of clearing such a load of rubble. The Republic did not have the funds for the project. After several attempts were made to deal with the problem, the stones were finally sold to a contractor named Bertrand, who, after long deliberation, finally met the purchasing requirements by the beginning of September 1796. Sadly, no documents survive from after the sale to provide the information that would explain how the recently uncovered fragments found their resting place under the rue de la Chaussée-d'Antin.

By 1792 two houses had been built on the site of the discovery. By 1795 it had become known that the owner of the property was Jean-Baptiste Lakanal-Dupuget, who had the Hôtel Moreau built. That name, however, was given to the house after its second owner, the general Moreau. Lakanal never lived in it.

Before the sale to Lakanal through Bertrand,

9

some of the broken sculptures must have been cut into more or less even cubes to facilitate their sale as construction material. But, even before the stones were cut up, some of the fragments—among them, perhaps, those found on the rue de la Santé—had already been removed from the group. The stones bought by Lakanal through Bertrand must have undergone a very discriminating process of selection and been separated into two lots. Heads and bodies—no matter how incomplete—were put into one lot. These were buried in the way described above. In the other lot were all the fragments that could not be identified with any part of a human form. These were probably used as building materials, since one such piece was found in a wall not far from the spot where the ditch was uncovered in 1977.

Jean-Baptiste Lakanal had a brother, Joseph, who as a true Jacobin had no sympathy for kings—dead or alive—and thought that his brother was "more royal than the king." Joseph was responsible for changing the spelling of the family name to Lakanal from the original Lacanal. His involvement with the Parliament of the Revolution did not prevent Jean-Baptiste from being incarcerated in the Luxembourg prison and from narrowly escaping the guillotine.

Jean-Baptiste Lakanal had to be a brave man, and only a charitable soul would have dared to give a decent burial to those pitiful fragments. As the owner of the grounds, he alone could have done it without anyone else's knowledge. The tender care with which the task was performed reveals a respect almost religious, as if the fragments were sacred relics that must be either buried or burned, but never thrown away. Jean-Baptiste Lakanal-Dupuget died, ruined, in 1800 after selling the hôtel to General Moreau. Although the documents that would explain Lakanal's role in all the transactions in this exciting story do not exist—or have not been found—there is no question that the gratitude of all of us interested in saving the past for the present and the future must go to that man, of whom we know so little.

The Banque Française du Commerce Extérieur, present owner of the Hôtel Moreau and of the fragmentary sculptures found under its grounds, decided from the start to donate this treasury to the French nation. But first it must be determined which museum will show the fragments in the best way and will try to collect all the other scattered pieces. Maybe someday more fragments will be found, but even if they are not, the discovery of 1977 has provided invaluable information. It started as a casual event, but after the discovery it was handled with great care and professionalism by M. François Giscard d'Estaing, now president of the bank and an archaeologist at heart, and by art experts in the field, especially M. Alain Erlande-Brandenburg.

The Background

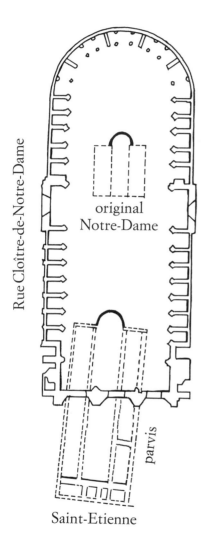

Rue Cloître-de-Notre-Dame

original
Notre-Dame

parvis

Saint-Etienne

A plan of the present Cathedral of Notre-Dame, showing where the sixth-century basilica of Saint-Etienne and the primitive cathedral of Notre-Dame once stood.

THE ILE DE LA CITE, in the heart of Paris, where the famous cathedral stands, was considered sacred ground from as far back as the first century A.D. The remains of a Gallo-Roman temple, probably erected during Tiberius's time, were found there in the eighteenth century. The first Christian church was probably built there about the fourth century and was named after the protomartyr Stephen, or Etienne. It is not, however, until A.D. 690 that a sixth-century basilica of Saint-Etienne, probably built on the site of the fourth-century church, is mentioned in the writings of Gregory of Tours. The foundations of this church were found in 1847, under the *parvis* of Notre-Dame. The original Notre-Dame was first mentioned in A.D. 775, and Charlemagne gave more importance to it than to the earlier Saint-Etienne. Part of the apse of the first Notre-Dame was found under the choir of the present church in 1858. Both churches suffered severe damage at the hands of the Normans in the ninth century, and by 1110 Saint-Etienne was in ruins. No more mention was made of Notre-Dame. After 1124 attempts were made to restore and renovate Saint-Etienne, and the work was financed by Etienne de Garlande, who died in 1150. While Garlande was trying to save the old Saint-Etienne, Abbot Suger was about to start the construction of the Royal Abbey of Saint-Denis, dedicated to the first bishop of Paris.

The fact is that in the mid-twelfth century, and during one of the most exciting moments in the history of architecture, Paris, which was already the royal city, did not have a proper cathedral.

Maurice de Sully became bishop of Paris in 1160 and decided to demolish the two old basilicas and reunite them on the same site within one grand cathedral. The construction started in 1163 to the east and a little to the south of the old basilica of Saint-Etienne. Notre-Dame was not finished until 1245.

The Portals of the West Facade

THE WEST FACADE, without its towers, is almost square (142 feet [43 meters] high and 135 feet [41 meters] wide) and has three portals: the central one is dedicated to the Last Judgment, the right to St. Anne, and the left to the Coronation of the Virgin. Two more portals give access to the north and south ends of the transept. The central and south portals will not be fully considered in the present study because no works from either of them is represented in the exhibition.

The west facade of the cathedral after the Revolutionary destruction, as shown in an engraving made after a daguerreotype of 1840.

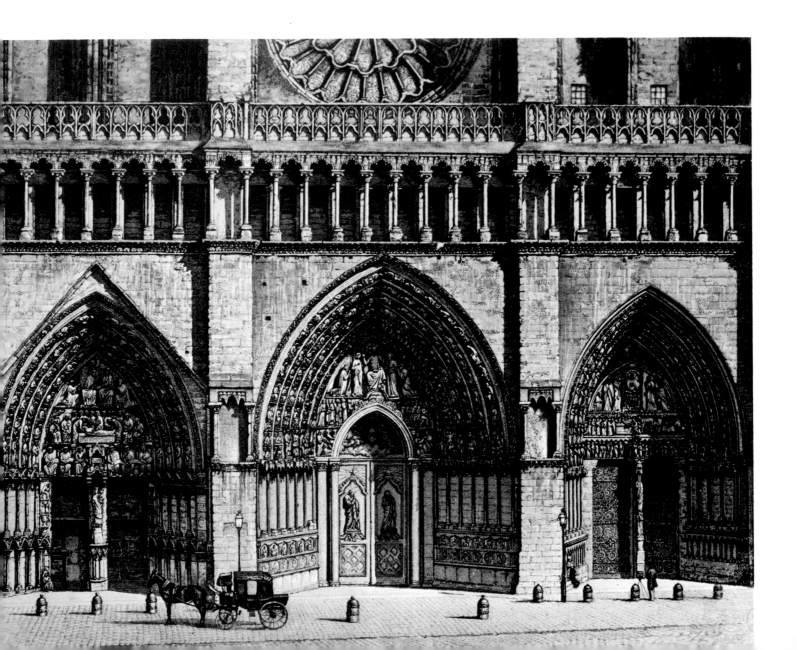

The Portal of St. Anne

The Portal of St. Anne presents problems that have puzzled art historians for many years. First of all, the style of its sculptures is considerably earlier than the style of those on the other portals and all the other sculptural decoration of the cathedral. The tympanum, the archivolts, and the trumeau (middle pillar) of the St. Anne portal escaped the iconoclasm of the French Revolution, but the statue of the trumeau, representing St. Marcellus of Paris, was damaged and suffered further disfiguration during the restorations by Romagnesi in 1818 and by Viollet-le-Duc in the later nineteenth century. It was finally replaced by a modern copy, and the original was stored away in the north tower of the cathedral.

It is for the Portal of St. Anne that the discovery of 1977 has the greatest importance. Now we can add several fragments of the sculptures of the jambs to the already extant parts, and that is much more than can be done for the other portals.

The problems of style and dating are still unsolved. It was always obvious that not all the sculptural elements of the St. Anne portal were intended for it and that they are earlier than the rest of the thirteenth-century facade. One possibility is that these sculptures might have been made for more than one earlier portal, as there are clear discrepancies in style among them.

In 1969 the archivolts, tympanum, and lintels were thoroughly cleaned. Once the grime of centuries was removed, all the parts were carefully studied, and the results were published by Jacques Thirion. What was always suspected is now a fact: apart from minor restorations of the eighteenth and nineteenth centuries, the whole sculptural ensemble is old. However, it was not made for the present St. Anne portal, and several adjustments and additions were necessary to make it fit.

The upper lintel was extended on both sides.

This was already observed by Viollet-le-Duc, who explained that the thirteenth-century additions indicated that the lintel had been made for a narrower door. Other adjustments were made to the archivolts, and there are discrepancies in size between the tympanum and the lintel, the former being considerably narrower. The lower lintel, representing scenes from the lives of Sts. Joachim and Anne, from which comes the name of the portal, belongs to the thirteenth century.

The Portal of St. Anne as it looks today.

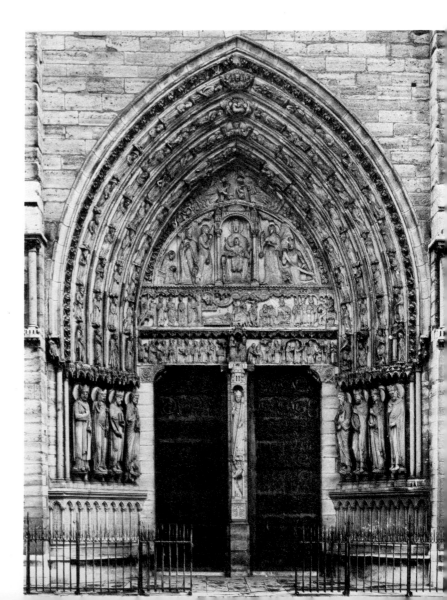

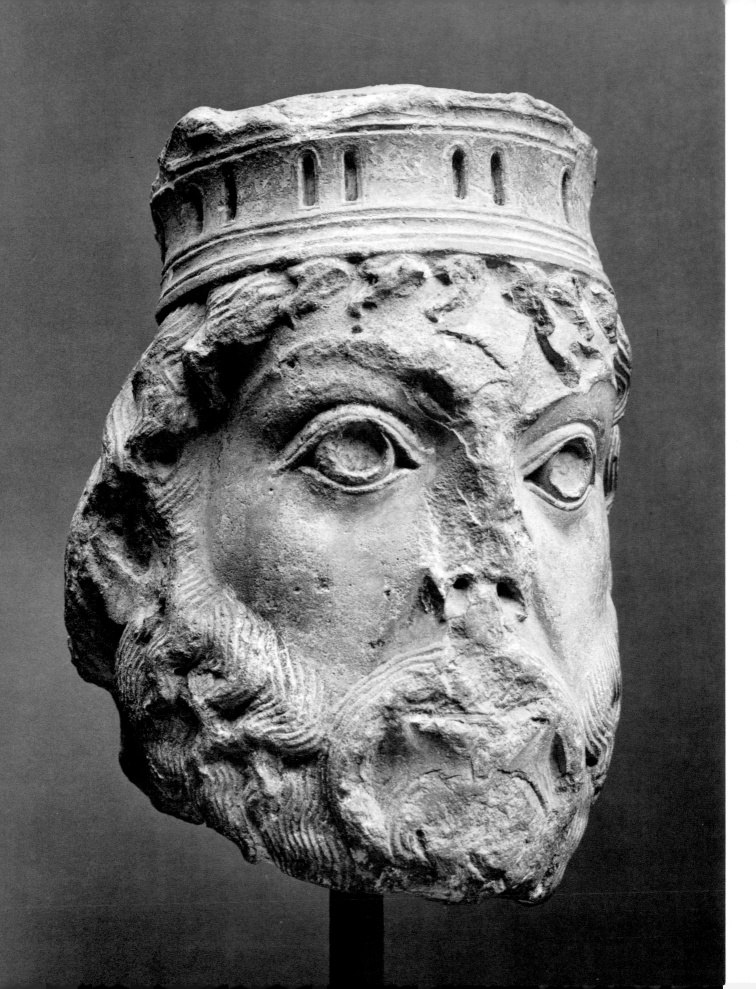

The tympanum represents the Virgin as *sedes sapientiae* (Throne of Wisdom), holding the Child in a frontal position and sitting on a canopied throne decorated with Romanesque architectural motifs. A censing angel stands on either side of the throne; a kneeling king is on the far right; a standing bishop and a scribe are on the left. The smooth drapery folds, of a decorative character, bring to mind some of the sculptures of the west portal of Chartres Cathedral, dated around the middle of the twelfth century.

The upper lintel, representing the Presentation of the Virgin at the Temple (part of it a thirteenth-century addition), the Annunciation, the Visitation, the Nativity, the Annunciation to the Shepherds, and the Three Magi before Herod and his counselors (part of the horses also added), is in an entirely different style that has no relationship to the sculptures of Chartres. The whole lintel, but mostly the scene on the right, representing the Magi and Herod, shows some relationship to the west portal of the Royal Abbey of Saint-Denis, still within the Romanesque tradition. The figures have large heads and round bulging eyes with inlaid pupils, heavy bodies, and large hands. The drapery and the hair and beards anticipate the more realistic and looser Gothic style.

This part of the lintel is especially interesting to us because it is closely related in style and iconography to the head acquired by The Metropolitan Museum of Art in 1938 (no. 1). The Museum's is the only extant head from the jamb sculptures of the St. Anne portal. With the help of the engravings made by Dom Bernard de Montfaucon in 1729, the Museum's head can be identified as that of King David from the right jamb of the portal. The David head, carved in a very hard and fine-grained limestone, has a polish that makes it look like marble. The large round eyes with deeply incised pupils, which were originally inlaid with lead, have a mesmerizing expression enhanced by the high eyebrows. Under the narrow crown—identical to the crowns of Herod and the Magi on the

Detail of the lintel of the Portal of St. Anne, showing the Three Magi before Herod. Photo: M.-C. Béthune, Paris.

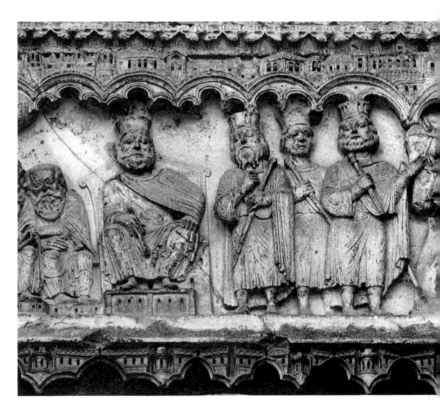

1. Head of King David

From the right jamb of the Portal of St. Anne, west facade, right
Limestone
H. 11¼ in. (28.6 cm.)
French, Paris, about 1150
The Metropolitan Museum of Art, Harris Brisbane Dick Fund, 1938. 38.180

Photo: The Metropolitan Museum of Art

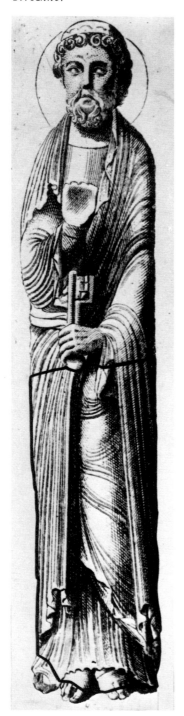

An engraving by Dom Bernard de Montfaucon, 1729, showing the figure of St. Peter from the left jamb of the Portal of St. Anne.

2. St. Peter (lower half of body)

From the left jamb of the Portal of
 St. Anne, west facade, right
Limestone
H. 48 in. (121.9 cm.)
French, Paris, about 1150
Found on the rue de la Santé, 1839
Musée du Louvre, Paris

lintel—the hair falls over the forehead in asymmetrical and rather wild locks and curls down close to the head, revealing part of the ears. The somewhat soft and fleshy cheeks contrast with the strongly carved high cheekbones and the intensity of the eyes. It is in all a magnificent head, by no means inferior to the earlier heads of the Abbey of Saint-Denis or any other works done in the transitional style between Romanesque and Gothic. The discrepancy between the style of the David head and the known dates of the construction of Notre-Dame made the head suspicious at one time, but after the cleaning of the upper parts of the portal it became clear that most of the components were carved at an earlier date than those of the other portals and that they were probably carved for the old basilica of Saint-Etienne during the attempts to reconstruct it after 1124 and before 1150.

One of the fifteen fragmentary sculptures found on the rue de la Santé in 1839 turned out to be the lower half of the statue of St. Peter from the left jamb of the Portal of St. Anne (no. 2). The identification was possible, once again, thanks to the engravings of Montfaucon. The St. Peter is the best preserved of all the figures, even though the upper half is missing. The style shows a high degree of sophistication in the contrast of the vertical folds on the left to the subtly curving ones

16

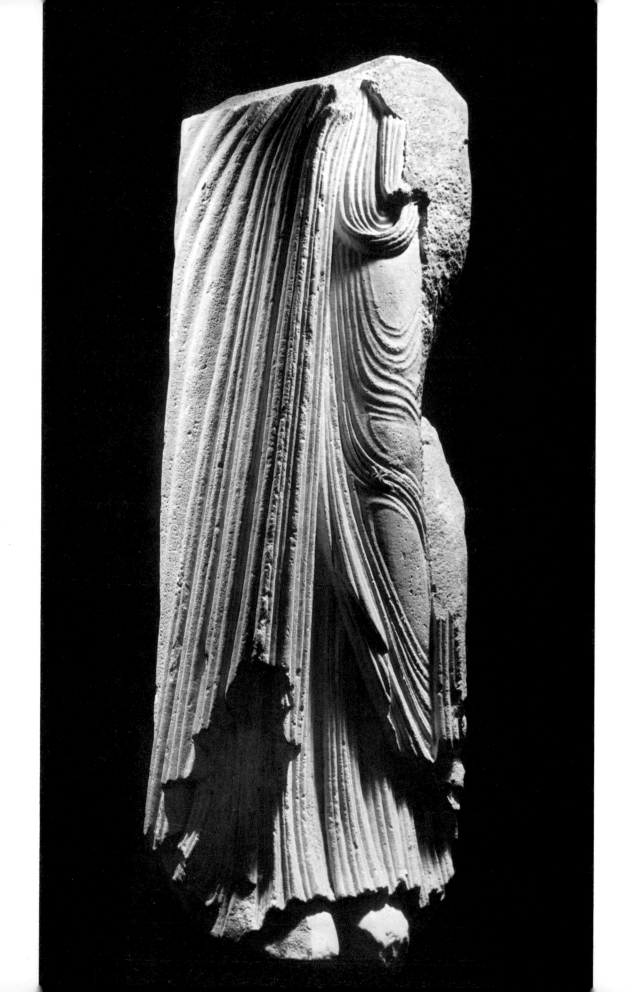

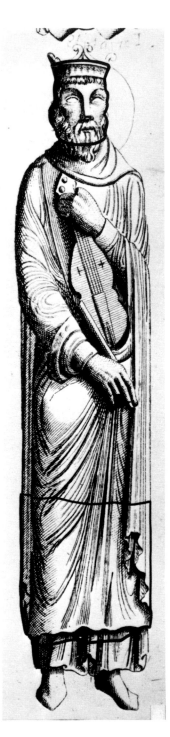

Montfaucon's engravings of the figures of King David (left) and St. Paul from the right jamb of the Portal of St. Anne.

3. King David (fragment of the body)

From the right jamb of the Portal of St. Anne, west facade, right
Limestone
H. 26 in. (66 cm.)
French, Paris, about 1150
Found at the Hôtel Moreau, Paris, 1977
Banque Française du Commerce Extérieur

4. St. Paul (three fragments of the body)

From the right jamb of the Portal of St. Anne, west facade, right
Limestone
H. (with filler) 52 in. (132 cm.)
French, Paris, about 1150
Found at the Hôtel Moreau, Paris, 1977
Banque Française du Commerce Extérieur

on the right. One is flat and rigid, the other rounded and almost sensual. It is really unfortunate that we have only Montfaucon's rather insipid interpretation of the head of this figure because we cannot ascertain from it how different the St. Peter head was from the David head. In 1977 a fragment of the lower part—above the feet—of the figure of David (no. 3) was found. Its style is clearly different from that of Peter. It is more rigid and flatter, and has a sketchy decorative, horizontal border that the folds of the garment do not disturb. Montfaucon did not copy that ornamentation, and other details may have escaped him as well.

Based on their style, the St. Peter and the David correspond to two different types. Following Montfaucon's engraving we can identify the statues on the right jamb of the St. Anne portal, starting at the trumeau, as St. Paul, David, a queen, and a king. On the left were St. Peter, a king, a queen, and another king. We now have three fragments of the St. Paul figure (no. 4), so that the statue is almost complete from the neck to the knees. These fragments, reconstructed with the help of

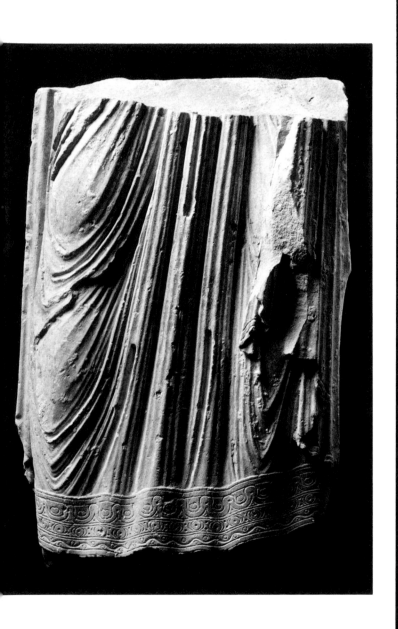
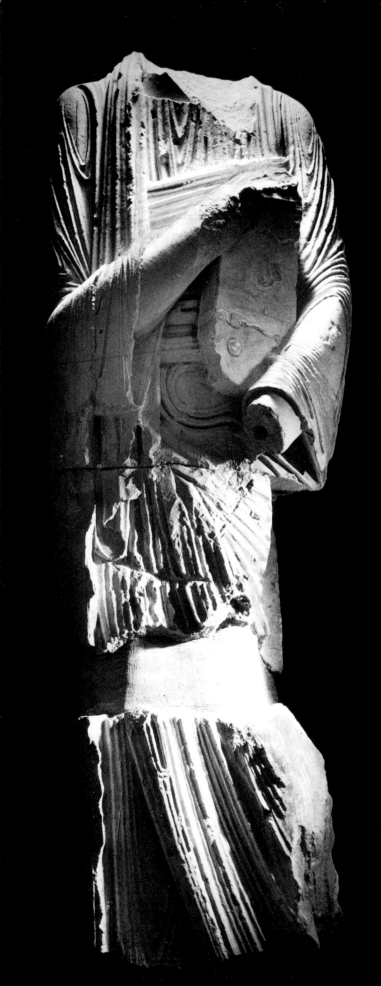

A biblical king from the left jamb of the Portal of St. Anne, as engraved by Montfaucon.

the engraving, give us an idea of a figure rather close in style to the David. In both, the tunic under the mantle ends at the ankles in a more or less straight line, and the drapery folds are angular and rigid. Nothing has been found of the queen, but three recovered fragments of the king show the same rigid style.

From the left jamb we have the St. Peter fragment and six parts of the king next to it (no.5), including the console on which he stands. The console takes the form of a crouching figure with a complicated garment of concentric pleats from the center of which the head emerges. Like St. Peter's garment, the king's tunic falls around the feet in rather thin pleats that curve slightly outward and reveal the points of the feet, while enveloping the sides and the heels. Nothing has been found of the queen from the left jamb, or at least nothing large enough to judge the style of the carving, but the Montfaucon engraving shows her in very much the same style drapery as that on the St. Peter figure and the king. It is possible that a beautiful console with another crouching figure, in much better condition than the one still attached to the feet of the king, may belong to the figure of this queen. It could also belong to the king at the end, of which only two rather small fragments have been found. That figure, according to the engraving, appears similar in style to the other figures on the left jamb of the portal.

The affinities and discrepancies among these statues give margin for another theory: not all the jamb figures and the elements above them come from the same portal. Though it is unusual, it is not impossible to find St. Peter and St. Paul together with figures from the Old Testament. We find a similar juxtaposition on the main portal of the Cathedral of Le Mans, dated before 1158, except that at Le Mans there are five figures on each jamb instead of the four found on the St. Anne portal.

The matter of the date has been a problem too.

20

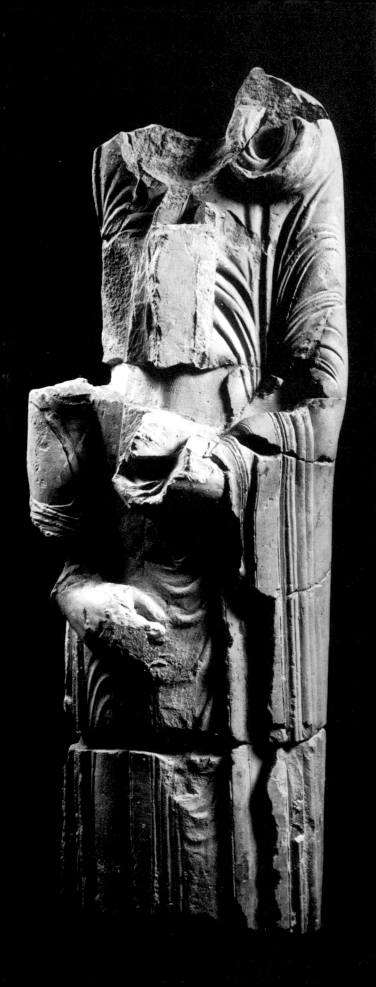

5. Figure of an Old Testament king (five fragments, including console)

From the left jamb of the Portal of St. Anne,
 west facade, right
Limestone
H. (upper part) 56 in. (142.2 cm.)
H. (lower part and console) 23 in. (58.4 cm.)
French, Paris, about 1150
Found at the Hôtel Moreau, Paris, 1977
Banque Française du Commerce Extérieur

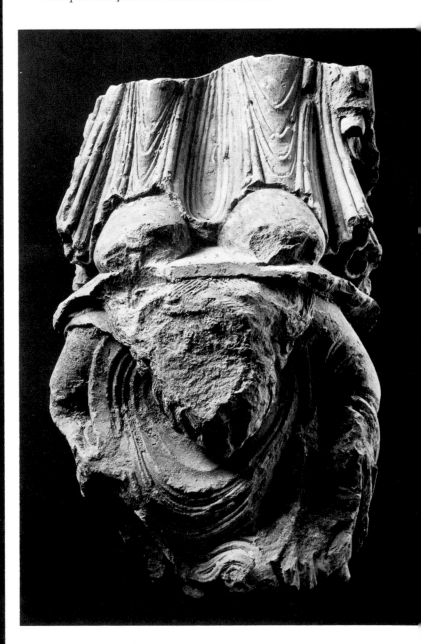

6. Head of an angel

From the left jamb of the Portal of the
 Coronation of the Virgin, west facade, left
Limestone
H. 15 in. (38.1 cm.)
French, Paris, about 1230
Found at the Hôtel Moreau, Paris, 1977
Banque Française du Commerce Extérieur

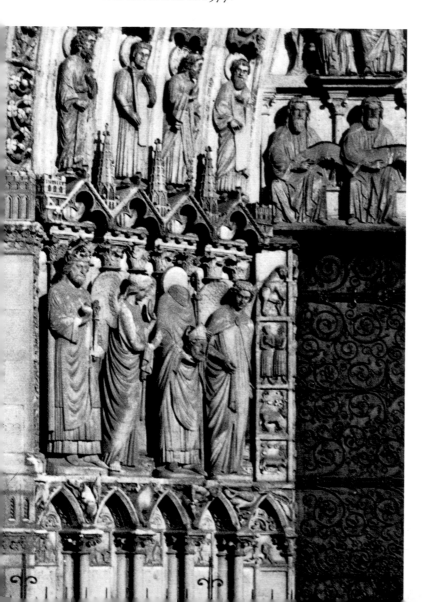

*Detail of the Portal of the Coronation of the Virgin as
it looks today. The angel on the right occupies the
position once taken by the angel whose head (no. 6)
was discovered in 1977.*

Until Thirion published his findings after the clean-
ing of the upper part of the portal, the dating had
been around 1160. (The Metropolitan Museum's
head was dated as late as 1165-70.) Thirion moved
back the date of the portal to 1150-1165. There is
an additional point, however, that should be con-
sidered. The restoration of the decaying Saint-
Etienne basilica was started after 1124 and was
financed by Etienne de Garlande, who died in
1150. There is no reason to believe that the statues
were not finished and put into place before Gar-
lande's death. This would make them more or less
contemporary with the west portal of Saint-Denis,
dated around 1140. Far from being the work of
one or more retardataire artists, the portal of St.
Anne has a strength and freedom of style that make
our earlier date even more convincing.

The Central Portal

The discovery of 1977 has also had a great im-
portance for the study of the other portals of Notre-
Dame and has provided a link between the Gothic
style of the first decade of the thirteenth century
and that of the last quarter of the same century.
The central portal had lost its trumeau before the
Revolution, probably to enlarge the passage for
religious processions. The statues of the apostles
from the jambs were all destroyed in 1793. One
fragment was discovered on the rue de la Santé,
and a headless body was found in the Seine. Some
small fragments were found in 1977, but none was
important enough to make a reconstruction pos-
sible. The style of the fragments of the portal
found so far seems inspired by classical models
and has been compared to that of the sculptures of
the Cathedral of Sens, dated about 1200.

The Portal of the Coronation of the Virgin

The Portal of the Coronation of the Virgin lost
all its jamb figures in 1793. Viollet-le-Duc recon-
structed it with figures of saints traditionally vener-
ated in the diocese. On the right are St. John the

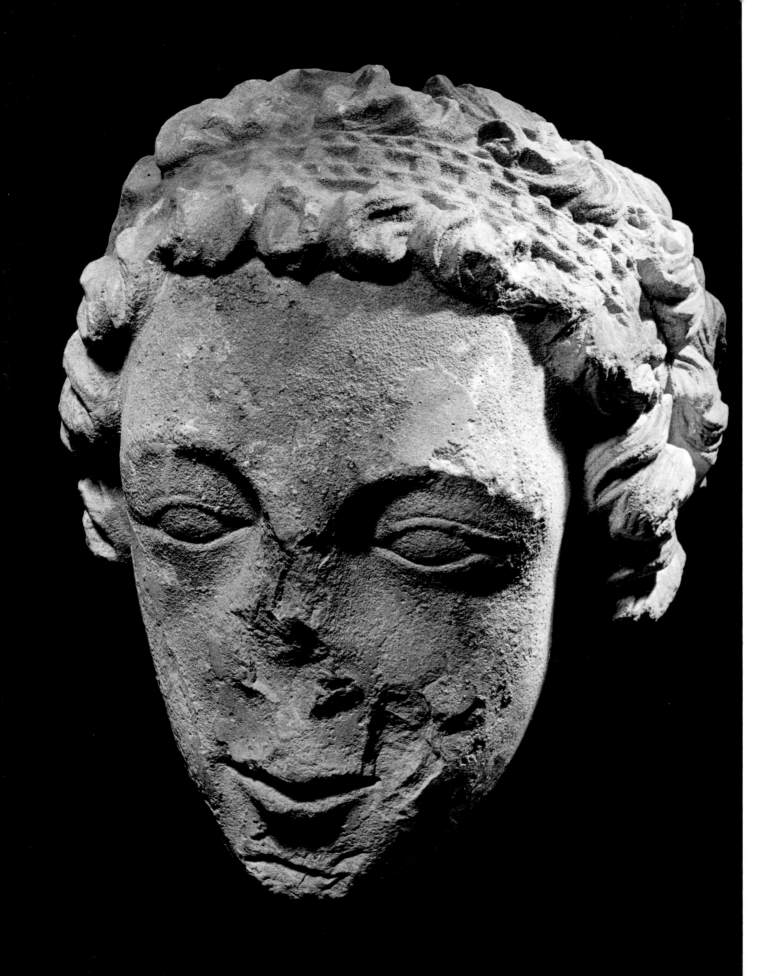

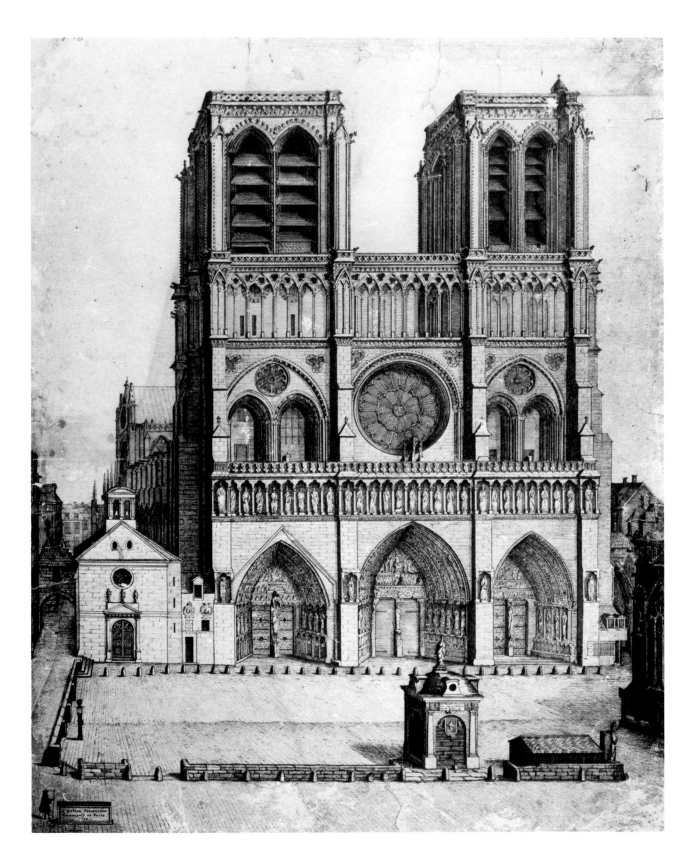

Baptist, St. Stephen, St. Geneviève, and a bishop that could be St. Germain. On the left are a king and St. Denis flanked by two angels. Until 1977 nothing had been found of this portal. We now have one of the most beautiful creations of the thirteenth century and the most exquisite of all the fragments found at the Hôtel Moreau. It is the head of an angel (no. 6), which corresponds to the angel next to the trumeau and to the left of St. Denis in the Viollet-le-Duc reconstruction. The face has soft and pure contours, almond-shaped eyes, and lips curved in a subtle smile. The hair, carved in bold curls, is held loosely in place by a jeweled band. No other sculptures from Notre-Dame can compare with this head. The smile evokes archaic Greek sculpture ("the Aeginetic smile"), which probably inspired the smile found on Parisian sculpture at the end of the thirteenth century. It is, according to Erlande-Brandenburg, "a demonstration of the preeminence of the artists who worked in Paris over those working in other regions," such as Reims.

The Gallery of the Kings

THE LOSS OF the twenty-eight sculptures representing the kings of Judah was the most complete and devastating for the Cathedral of Notre-Dame. The gallery was thought to be later than the three portals, dating between 1220 and 1230, but it was impossible to know how the figures looked. Viollet-le-Duc carved them in a nineteenth-century interpretation of the innovative style of the 1240s, but the findings of 1977 demonstrate that actually the kings were carved in a traditional style. Some of

7. Head of king no. 6

From the Gallery of the Kings, west facade
Limestone, with traces of polychromy
H. 28 in. (71.1 cm.)
French, Paris, about 1230–40
Found at the Hôtel Moreau, Paris, 1977
Banque Française du Commerce Extérieur

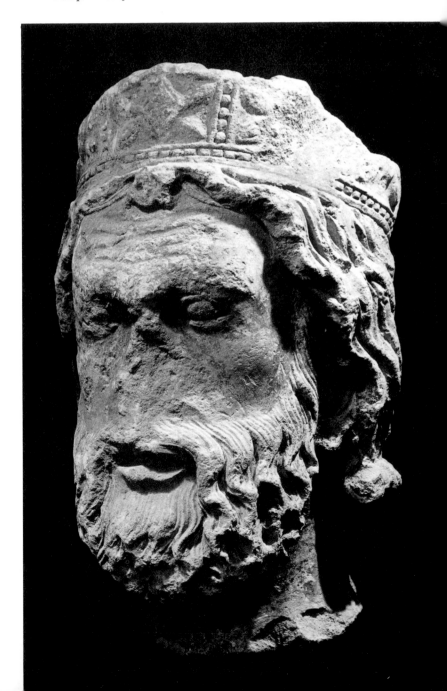

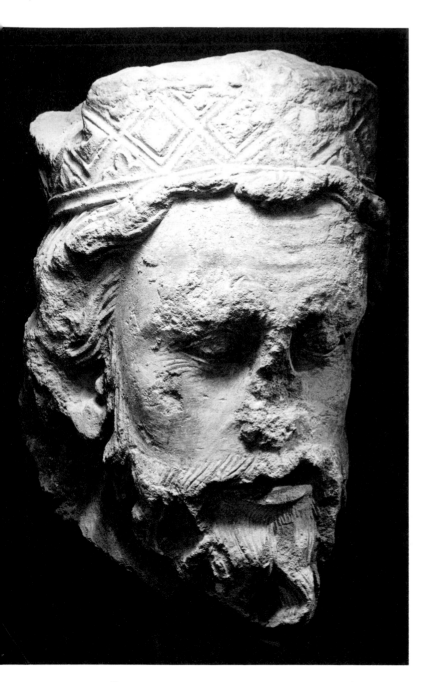

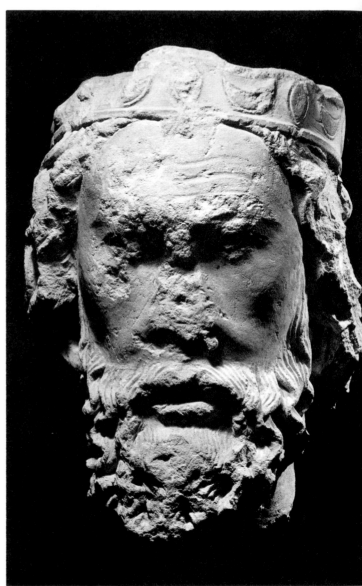

8. Head of king no. 12

From the Gallery of the Kings, west facade
Limestone, with traces of polychromy
H. 26 in. (66 cm.)
French, Paris, about 1230–40
Found at the Hôtel Moreau, Paris, 1977
Banque Française du Commerce Extérieur

9. Head of king no. 14

From the Gallery of the Kings, west facade
Limestone, with traces of polychromy
H. 26 in. (66 cm.)
French, Paris, about 1230–40
Found at the Hôtel Moreau, Paris, 1977
Banque Française du Commerce Extérieur

the heads, however, anticipate the changes that took place later in the century. They stand just between the past and the future, providing the missing link to make the study of Gothic sculpture of the first half of the thirteenth century much more understandable.

The general style of the heads is quite consistent. All have similar crowns, or rather bands, since all the fleurons had been broken off before the statues were destroyed. The hair usually covers the ears, and most of the faces have short beards and mustaches—sometimes curly, sometimes ending in two points curved inward. Only two of the heads are beardless and have a different hairdo, more like the one in fashion when the sculptures were carved. It is amazing how carefully the features are rendered, enhanced by very lively polychromy, when one considers that they were made to be placed very high on the facade. They still remain very impressive, in spite of their mutilations, and much of the polychromy has been preserved.

It is obvious that not all of the heads were carved by the same hand. Among the twenty-one found at the Hôtel Moreau (some of them fragments), head no. 6 (no. 7)* is unique, as if it had come from an entirely different artist using a different model. It shows a more progressive approach; it is more realistic, more full of life. Luckily, the neck is preserved in this piece and it conveys a majestic carriage that the other heads lack. The type of hairdo, with a little forelock showing under the crown and an S-shaped mustache, are characteristics that were more fully developed later in the thirteenth century. It is sad that no fragments of any of the bodies have been found. They were probably cut into small pieces and may be scattered in walls throughout Paris. Dreadful thought!

*All the heads from the Gallery of the Kings found at the rue de la Chaussée-d'Antin have been numbered, since no other identification is possible. The numbers in parentheses correspond to the catalogue numbers in the present publication.

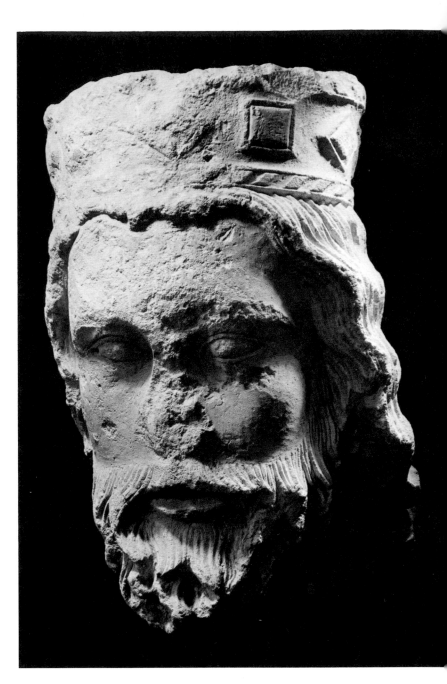

10. Head of king no. 15

From the Gallery of the Kings, west facade
Limestone, with traces of polychromy
H. 26 in. (66 cm.)
French, Paris, about 1230–40
Found at the Hôtel Moreau, Paris, 1977
Banque Française du Commerce Extérieur

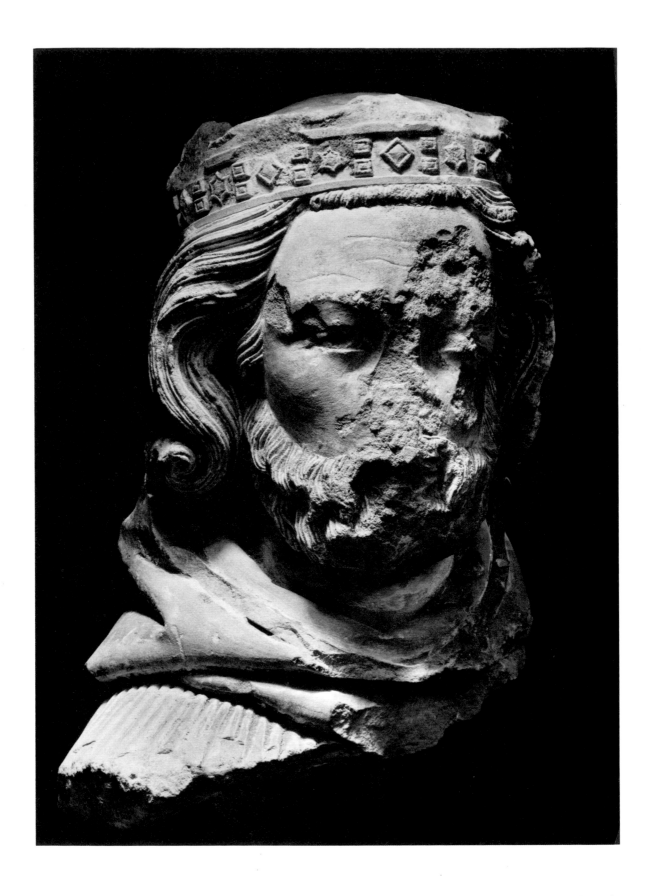

The North Portal

THE north portal of the transept is the latest in style and shows the stage in development already forecast in the head of king no. 6, datable around 1240. A similar style is found in the tympanum of the central portal of the west facade and in part of its lintel. This highly developed style flourished in one of the most beautiful buildings of the thirteenth century, only a few yards from Notre-Dame—the Sainte-Chapelle.

The north portal was made in 1245, and its tympanum shows scenes of the Life of Christ and the Miracle of St. Theophilus; the archivolts show angels, saints, and other figures. Of the sculptures of the lower part, only the Virgin and Child of the trumeau were preserved. According to a description by Lebeuf in 1754, the jambs had figures of the Theological Virtues on the right and of the Three Magi on the left. Two of the heads found at the Hôtel Moreau have been identified by Erlande-Brandenburg as belonging to this portal. One of them represents a king with S-shaped woven hair rolled up to shoulder level, wearing the hood of what seems to be a traveling cloak (no. 11). The head has a considerable amount of polychromy left on it, and, in spite of the missing nose and damaged

11. Head and part of body of a king

Perhaps one of the Magi from the north portal
Limestone, with traces of polychromy
H. 16 in. (40.6 cm.)
French, Paris, about 1245
Found at the Hôtel Moreau, 1977
Banque Française du Commerce Extérieur

The north portal of the transept as it looks today.

12. Head of a woman

Perhaps one of the Theological Virtues from the north
 portal
Limestone
H. 13 in. (33 cm.)
French, Paris, about 1245
Found at the Hôtel Moreau, Paris, 1977
Banque Française du Commerce Extérieur

right cheek, is one of the most beautiful examples of the sculpture of the period. The Virgin of the trumeau is turned slightly to her left, holding the Child as if offering him for adoration. With the upper part of the Child missing, it is hard to know which way he was facing. One cannot be sure if the Three Magi were on the left, as Lebeuf wrote, or on the right, as the posture of the Virgin seems to indicate.

The other head from this portal, also beautiful, represents a young woman with fluffy, floating hair, very elongated almond-shaped eyes ending at the temples in a triple line, and fleshy lips (no. 12). She could be one of the Theological Virtues described in Lebeuf. There is no reason to accept or reject the provenance of this head as the north portal. The style seems different from that of the king; and it does seem strange that if both heads were on the same portal one should have so much polychromy left on it while the other has none. The

female head bears no similarity to the Virgin of the trumeau, but it does relate to some of the figures of the tympanum. The frontality of this head does not provide us with a clue as to whether it was placed on the right side or the left.

It is possible that future research will bring a solution to the reconstruction of this portal, or that luck and perseverance will uncover some more fragments belonging to it.

If we are to believe in miracles, the discovery of the buried fragments of the sculptures of Notre-Dame was one. This famous cathedral was more a symbol than a reality in the eyes of art lovers. What we saw was mostly a nineteenth-century interpretation of what should have been. Now we can dream and see Notre-Dame as it really was. All those mutilated heads and bodies have brought to us a reality that we believed lost and a knowledge we thought we would be denied forever.

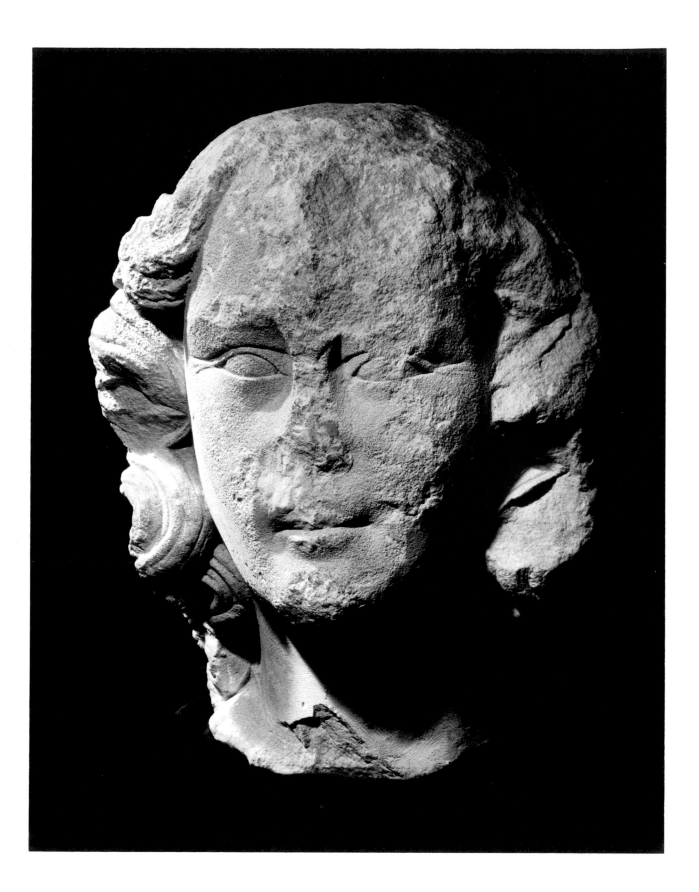

SELECTED BIBLIOGRAPHY

Montfaucon, Dom Bernard de. *Monumens de la monarchie françoise,* vol. 1. Paris, 1729, pl. 8.

Mercier, Sebastien. *Le nouveau Paris,* vol. 6. n.d., pp. 85-87.

Lebeuf. *Histoire de la ville et de tout le diocèse de Paris,* vol. 1. Paris, 1863.

Aubert, Marcel. *La cathédrale Notre-Dame de Paris.* 2nd ed. Paris, 1919.

Rorimer, James J. "A XII century head of King David from Notre-Dame." *Metropolitan Museum of Art Bulletin* 35, 1940, pp. 17-19.

Saint Girons, Simon. *Souvenir du general Moreau en son Hôtel de la Chaussée-d'Antin.* Paris, 1961.

Thirion, Jacques. "Le plus anciennes sculptures de Notre-Dame de Paris." *Comptes rendus de l'Académie des Inscriptions et Belles-Lettres,* 1970, pp. 85-112.

Sauerländer, Willibald. *Gothic Sculpture in France, 1140-1270.* New York, 1972, pp. 404-406, 450-457, 470-474, pls. 1-3, 4-17, 40, 41, 50, 144-156, 184-188.

Erlande-Brandenburg, Alain. "Les sculptures de Notre-Dame de Paris récemment découvertes." *Le petit Journal,* 1977. Réunion des musées nationaux, n.s., 46.

Giscard d'Estaing, François. "Hasards d'une découverte." *Archéologia* 108, 1977, pp. 6-9.

Fleury, Michel. "Les statues-colonnes du portail Sainte-Anne découvertes rue de la Chaussée-d'Antin." *Archéologia* 108, 1977, pp. 10-18.

————. "Comment la façade de Notre-Dame retrouve une partie de ses sculptures." *Archéologia* 108, 1977, pp. 20-34.

Erlande-Brandenburg, Alain. "L'extraordinaire génie des sculpteurs parisiens: un ouvrage pour l'homme et pour Dieu." *Archéologia* 108, 1977, pp. 36-51.

————. "La statuaire de Notre-Dame de Paris avant les destructions révolutionnaires." *Bulletin Monumental* 136-III, 1978, pp. 213-266.

Giscard d'Estaing, François, Fleury, Michel, and Erlande-Brandenburg, Alain. *Les Rois retrouvés—Notre-Dame de Paris.* Paris, 1977.